A Successful Artnership

By
Heather K. Eddy Artwork
Brian K. Eddy Poems

© 2017

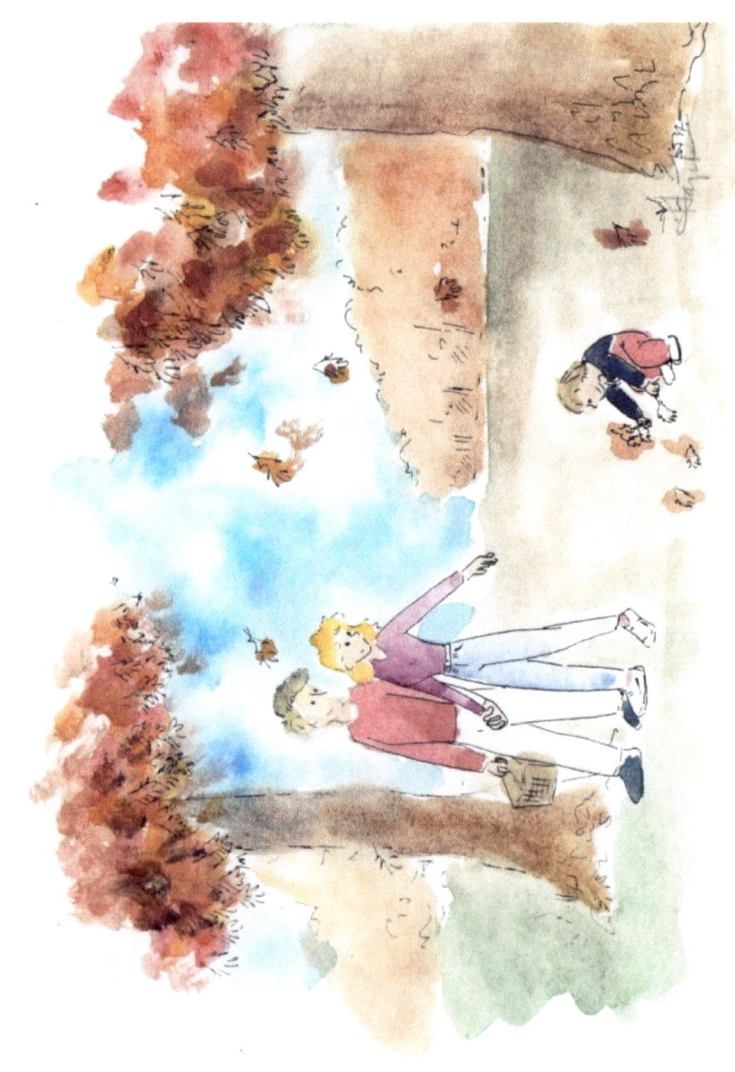

Fall is in the Air

How fragile the silence,
Filling the space between trees,
A whip-like crack of leaves,
As we stroll through the glade.

Crisp air, cool and fresh,
Laced with Fall and smoke,
Herald winter's approach,
Fading, but alive just the same.

He gather's maple flowers,
Cast from the branch, adieu,
Red-gold in endless hues,
Joys in their crunchy touch.

Come, we mustn't dawdle,
We have places to go,
And so much to know,
That we forget the simple things.

10/17/15

Commentary p56

Introduction

Art is an expression of one's soul. What medium you use, be it oils, sculpture, watercolors or poetry, is quite unimportant. The creation of art opens a portal to the innermost feelings of the Creator.

What bravery therefore, is shown before the world. "Look at me", they cry, "I hurt, I love, I hope". And they beg the audience to share in their emotions.

An Expanded Artnership is a continuation of the adventure begun in *A Creative Artnership*. Heather's beautiful art pieces paired to my own poetic flights.

In each case, the poem has been inspired by the artwork and as such owes its very existence to the physical piece.

We hope you will enjoy this feast for the eye and the heart.

Table of Contents

Fall is in the Air p2 (w)

Introduction p5

The Little Red House: He's Here p8 (w)

White Purple and Gold p10 (p)

Who is Out There? p12 (w)

Wizard Tim p14 (w)

A Multitude p16 (b)

What a Mess p18 (w)

The Little Red House: Why? p20 (w)

Adam's Apple p22 (p)

Nitwit p24 (c)

Starscape p26 (w)

Hearts p28 (p)

The Holy Ghost p30 (w)

The Written Star p32 (b)

Emergence p34 (w)

Asters p36 (w)

One Among Them All p38 (p)

Darker Than the Blues p40 (w)

The Little Red House: Darkest before the Dawn p42 (w)

Wine p44 (b)

Aberrations p46 (p)

Through the Gate of Night p48 (w)

The Little Red House: Duplex p50 (p)

Enos p52 (c)

Greatness p54 (w)

Commentary pp 56-80

Acknowledgements p82

Rejected Works p81

About the Authors p83

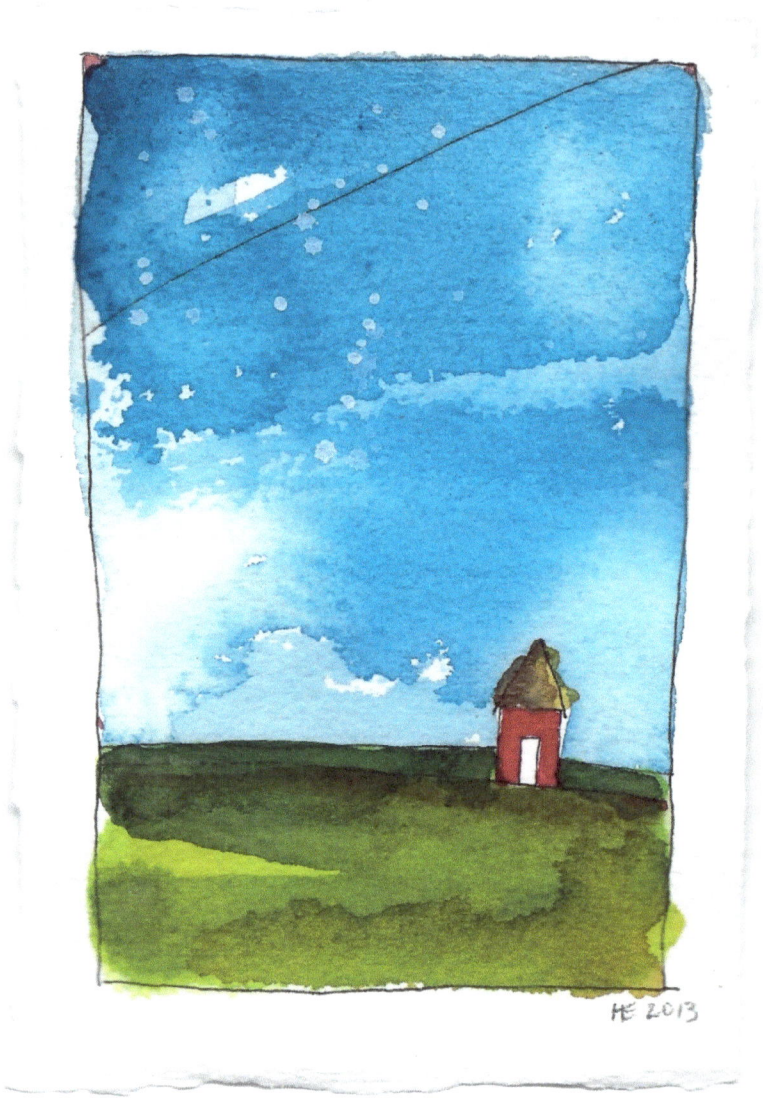

The Little Red House: He's Here

"He's here", she thought with giddiness,
As the stranger came to call,
"The one who's meant to fill my life,
With joy, friendship and all."

"He's here", she thought though with a grin,
While gazing at his face,
"he's not Adonis but he'll do",
Her heart did not quite race.

"He's here", she thought resignedly,
As flaws began to show,
The more she looked, the less she liked,
The more she got to know.

"He's here, she thought, irritated,
"He's rotten to the core",
But she would stay if he'd mend his ways,
Then he was there, no more.

10/16/15

Commentary p57

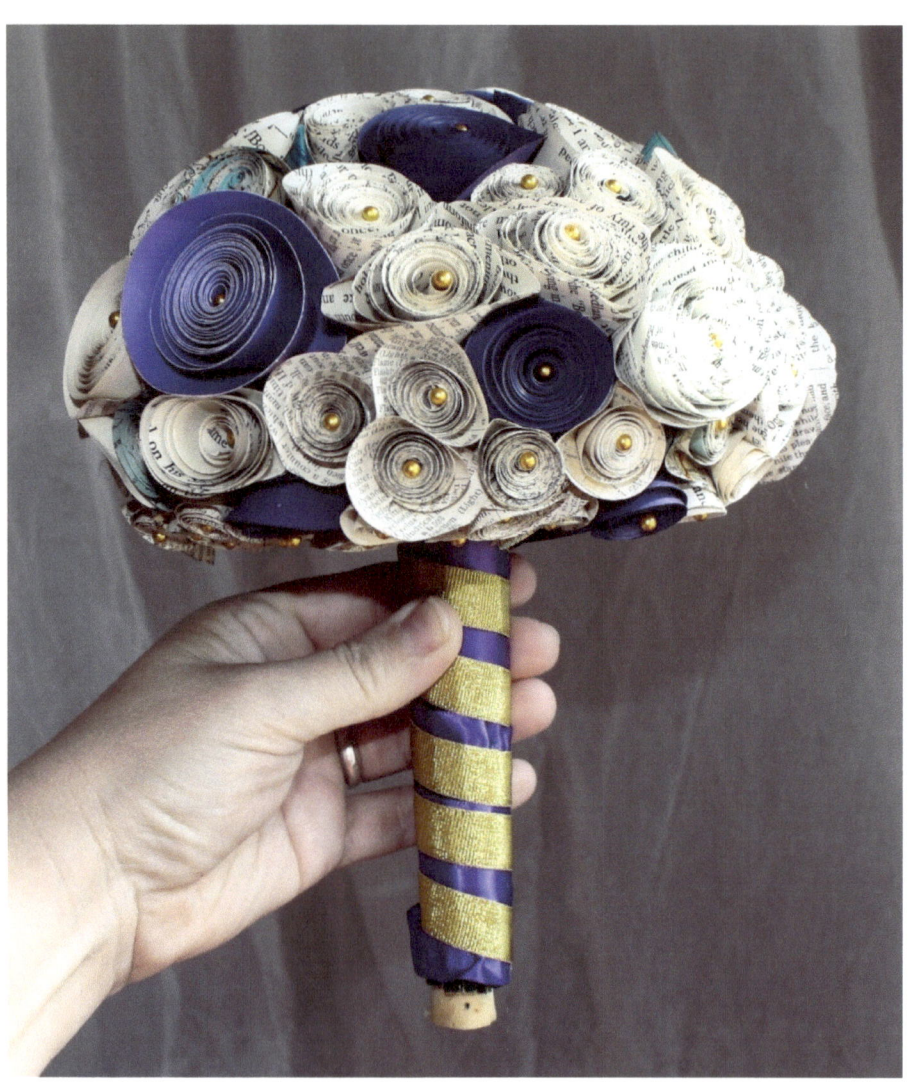

White and Purple and Gold

I stand here all dressed in white,
Ready to take your hand,
Our future together's bright,
As bouquets in my hand.

Purple flowers passionate,
This life is sure to be,
Made of words, a symbol that,
Our hearts and minds shall meet.

All wrapped-up in golden lace,
Pure love undefiled,
It represents a hopeful place,
Free of hate and guile.

Hidden midst the flowers mine,
Unseen by all but we,
A small flask of spicy wine,
My soul it burns for thee.

10/16/15

Commentary p58

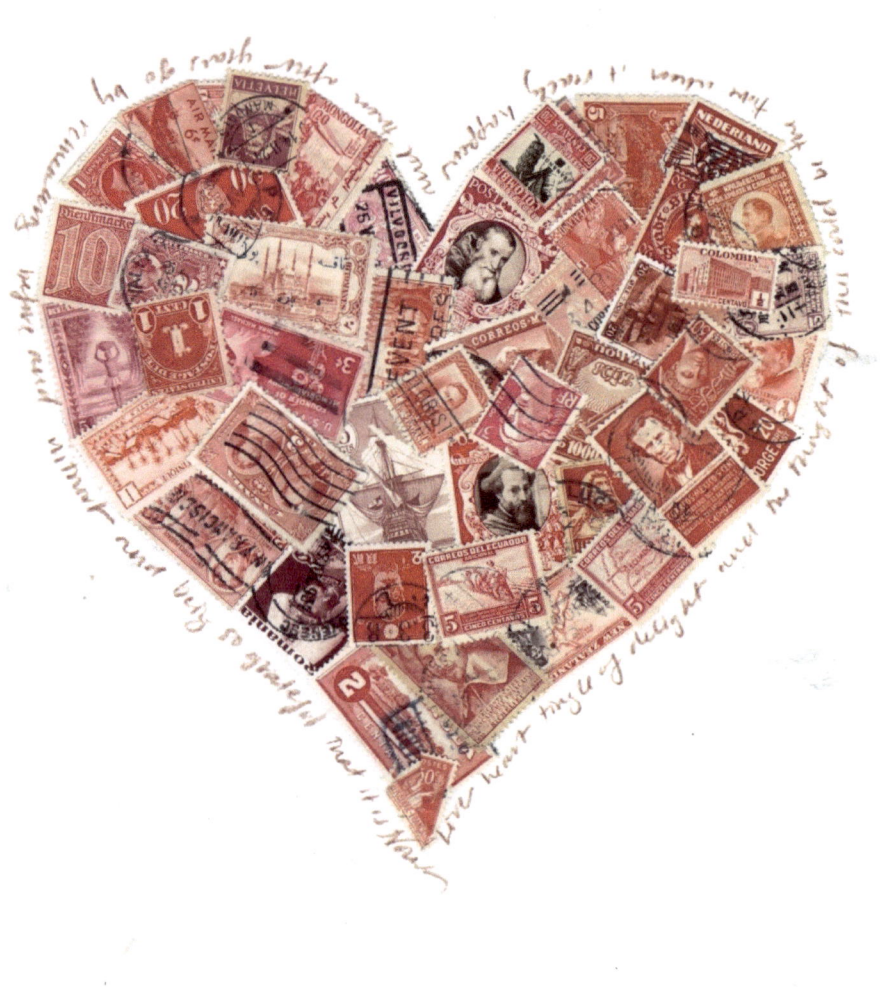

Who is Out There?

Who is out there I could love?
With a heart that would be true?
Who is out there with the face?
To thrill my soul anew?

I do not need perfection,
Though goodness would be nice,
I do want some reflection,
A deep soul's my price.

Perhaps I should stop waiting,
Go out and just see,
What might be on offer,
In case they're waiting there for me.

10/17/15

Commentary p59

THE SEER OF SLABSIDES 7

and his constant joy in living, his utter naturalness and naïveté amounted to genius. They were his genius — and a stumbling-block to many a reader. *Similia similibus curantur*, or a thief to catch a thief, as we say; and it certainly requires such a degree of simplicity to understand Burroughs as few of us possess.

Not every author improves upon personal acquaintance, but an actual visit with Burroughs seems almost necessary for the right approach to his books. Matter and manner, the virtues and faults of his writings, the very things he did not write about, are all explained in the presence of a man of eighty-three who brings home a woodchuck from the field for dinner, and saves its pelt for a winter coat. And with me at dinner

Wizard Tim

Wizard Tim sank in his chair,
For a winter's read,
But the sun had gone to bed,
Long before Tim's need.

He rummaged for a candle,
Cast a bit of light,
But all of them had been used,
In the spell last night.

Tim thought about a potion,
That'd make crickets glow,
But he'd have to mix it in,
Cauldron's dirty bowl.

Maybe he could cast a spell,
To make the room bright,
If he couldn't break it though,
He'd be up all night.

Just then some pretty flowers,
Bulbs of golden red,
Looked right into Tim's window,
This is what he said,

"The bees may draw forth nectar,
I shall draw forth light",
And by a wave of his wand,
He could read all night.

10/17/15

Commentary p60

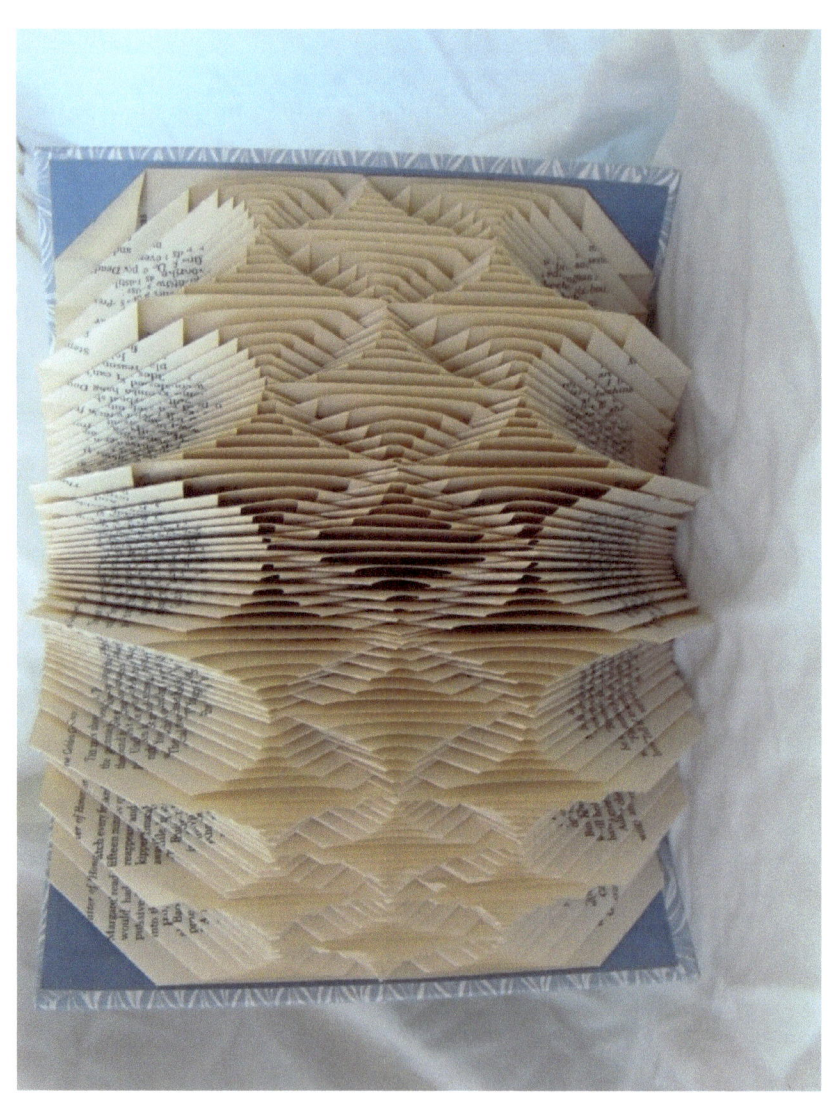

A Multitude

Are we forced so close together,
We have no room to grow?
Somehow deprived of freedom's space,
A right we'll never know?

Or perhaps we draw together,
So that we might hold hands?
Invite some to our space,
Because alone we cannot stand.

Pure sweet love brings us together,
Close enough to feel,
Yet then allows us to let go,
They'll return when love is real. 10/15/15 Commentary p61

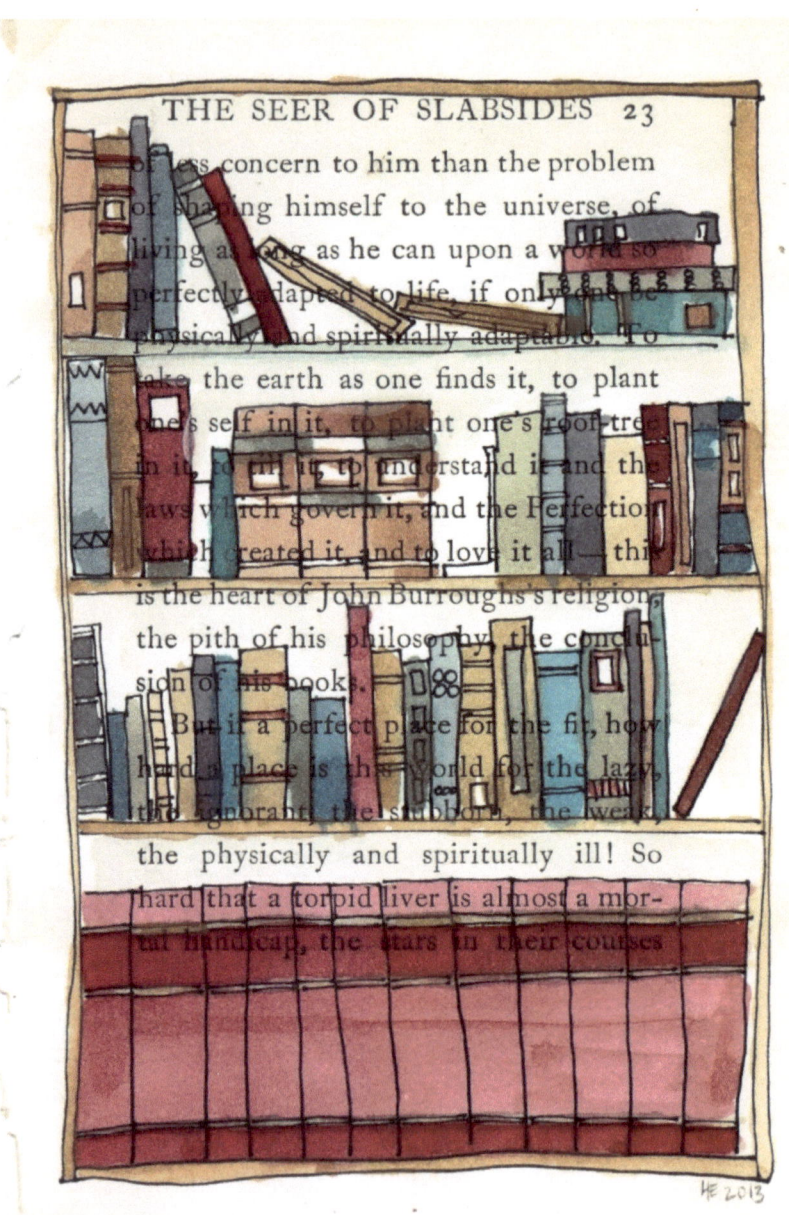

What a Mess

On the bookshelf in four rows,
Five dozen volumes took their repose,
Art, science, poetry, prose,
Multiple book sets and single tomes.

Encyclopedia prim,
Bound by red leather, solemn and grim,
Being forever neat and trim,
The mess above? They took a view dim.

In a literatural way,
The shelves above were happy and gay,
"Pfft", how they were put away,
'Cause they were read most every day.

Neat bookshelves are such a bore,
Time wasted cleaning, not reading more,
Turn just one page, what's in store?
The written word is what I adore.

10/16/15

Commentary p62

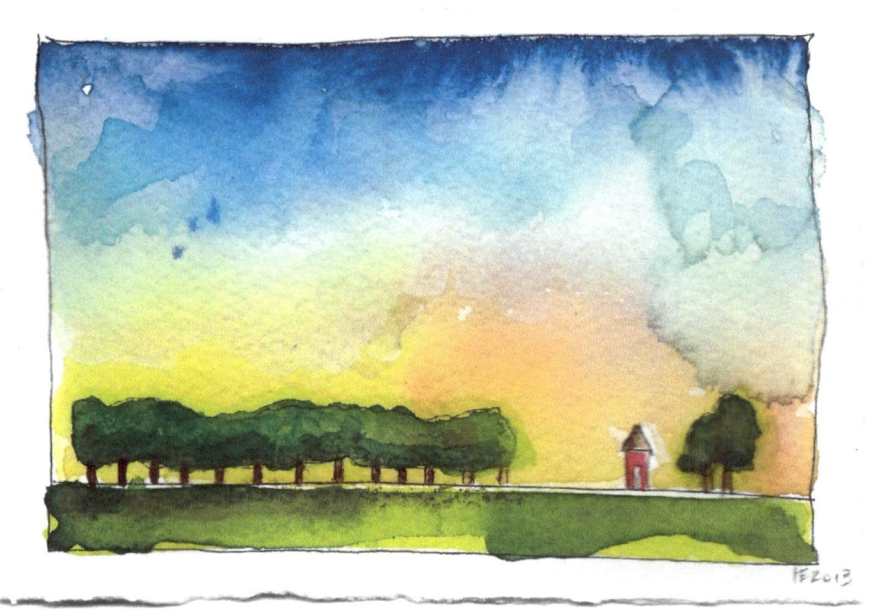

The Little Red House: Why

Why wasn't he a good man?
Is that too much to ask?
To simply, not be evil,
Wear your face, not a mask.

Why was I just so willing,
To settle for that guy?
When I am worth so much more,
Than disrespect and lies.

Why haven't you brought him Lord?
You know I've not been shy,
I've almost giv'n up hope,
Why keep asking Him, "Why?"

10/18/15

Commentary p63

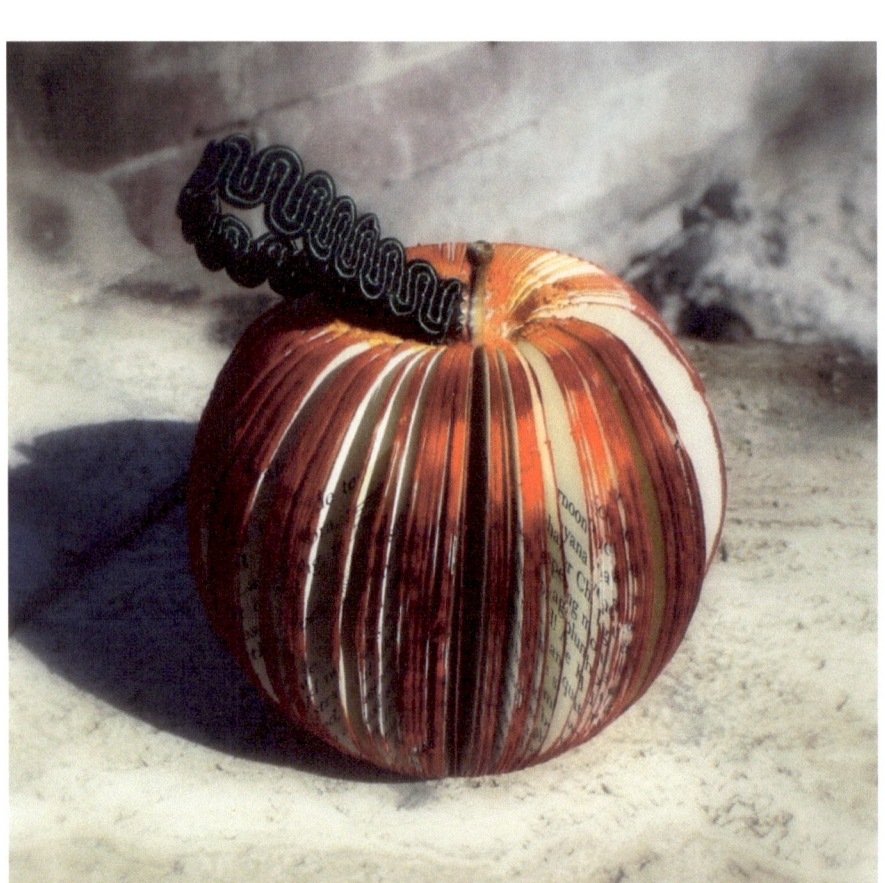

Adam's Apple

Adam's apple may have been,
The bitterest of fruits,
It cast us from the garden,
But laid our mortal roots.

Though sinful in its eating,
The knowledge that it bore,
Gave us the chance for wisdom.
To progress so much more.

Knowledge and understanding,
Found in the written word,
Convey the mind of ages,
And witness what you've heard.

So take a slice of apple,
To gain the wisdom there,
Unless you are too afraid,
To do what Adam dared.

10/17/15

Commentary p64

Nitwit
Oddment
Blubber
Tweak

· THANK YOU ·

Nitwit

"Nitwit", said the sixth year,
As I climbed off the train,
How was I to know that,
My toad was now passé?

Oddment here, bits and bobs,
The things I'd need for school,
Spilled out of my ripped bag,
Quoth the Baron, "So uncool".

Blubbler in my pillow,
Crying throughout the night,
"Why is it always me?"
Detention for a fight.

"Tweak his nose," Fred advised,
"He's just a little punk",
But I have better plans,
Once my legs get unstuck.

Thank you, Hermione.

10/17/15

Commentary p65

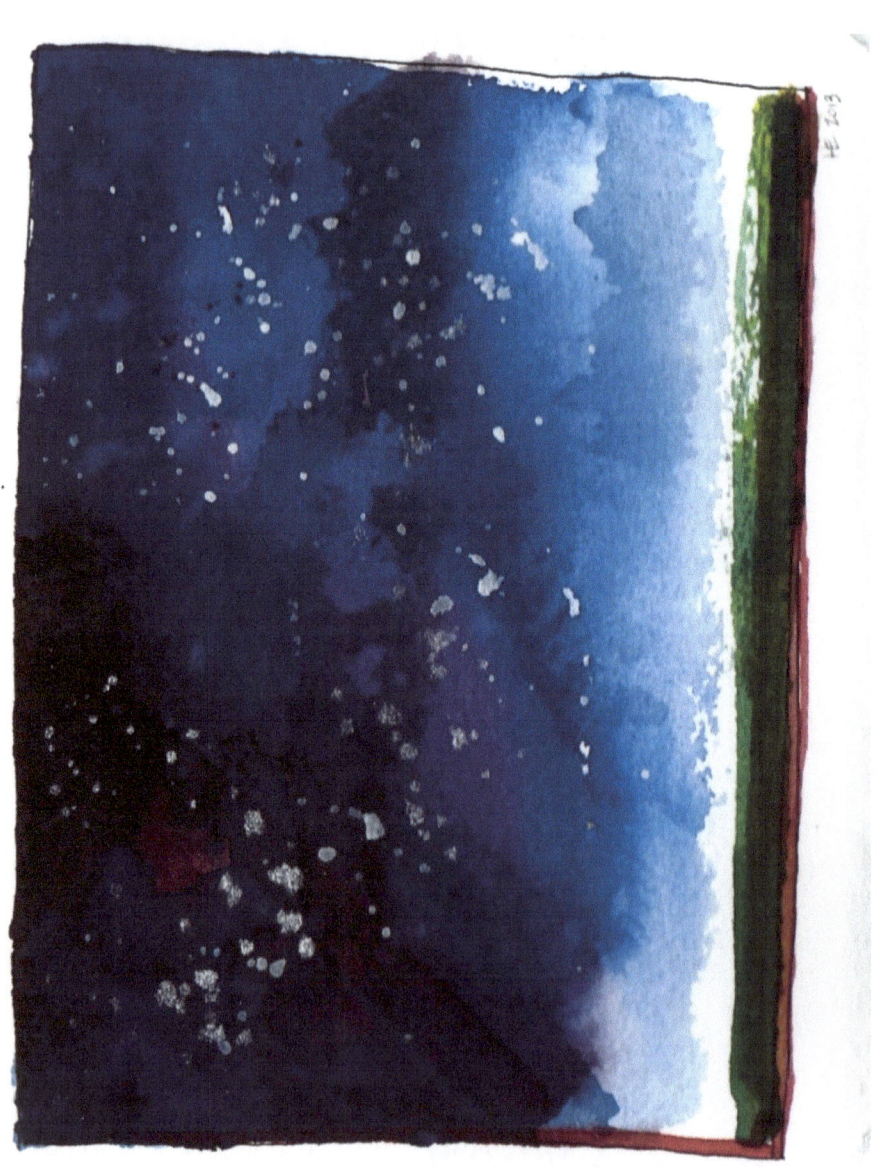

Starscape

How very small I feel,
Looking at the sky,
Wonder if what's real is real.
Life, is there a why?

If there's nothing out there,
No universal God,
Then we are tragic heirs.
Meaningless facades.

'Cause Man alone cannot,
Answer certainly,
The Dane's most basic plot,
Be or not to be.

Without Divine purpose,
Reason to exist,
Our grand conceits are just,
Empty smoke and mist.

We live, we die, no more,
Take joy as we can,
Then we lie down in gore,
Ephemeral Man.

But what if God is real?
An eternal plan?
Rise above the mortal,
By Him take my stand.

10/14/15
Commentary p66

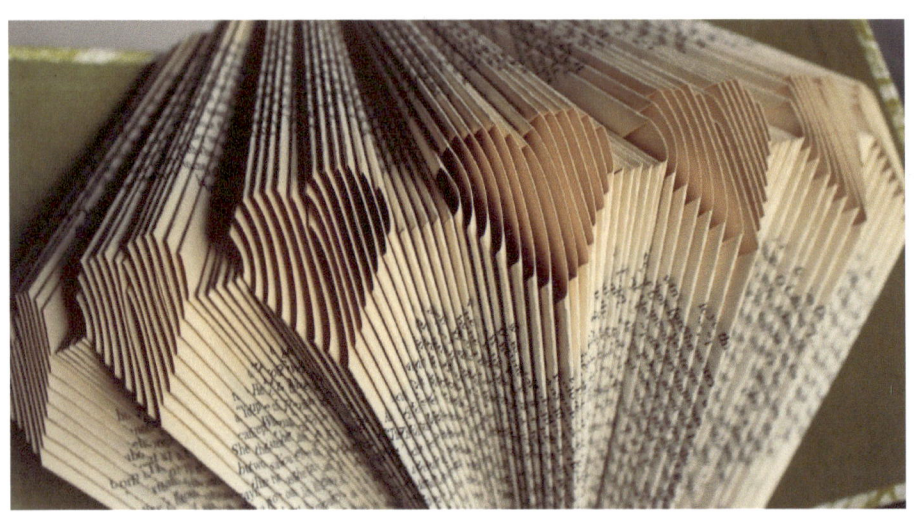

Hearts

Every woman has three hearts,
Which you can clearly see,
They are always on display,
Endless variety.

The first is her pretty face,
Round eyes, soft cheeks, cute chin,
Know what her expression shows,
Means more than words have been.

Second comes a bosom fair,
Smooth curves to neck's hollow,
If she wants you to be there,
They can make you follow.

In third on our jaunty list,
Is one that comes behind,
Be wide or slim, full or tight,
She knows what's on your mind.

A final heart is hidden,
Just between you and me,
You can tell what she's thinking,
Just read the other three.

10/15/15

Commentary p67

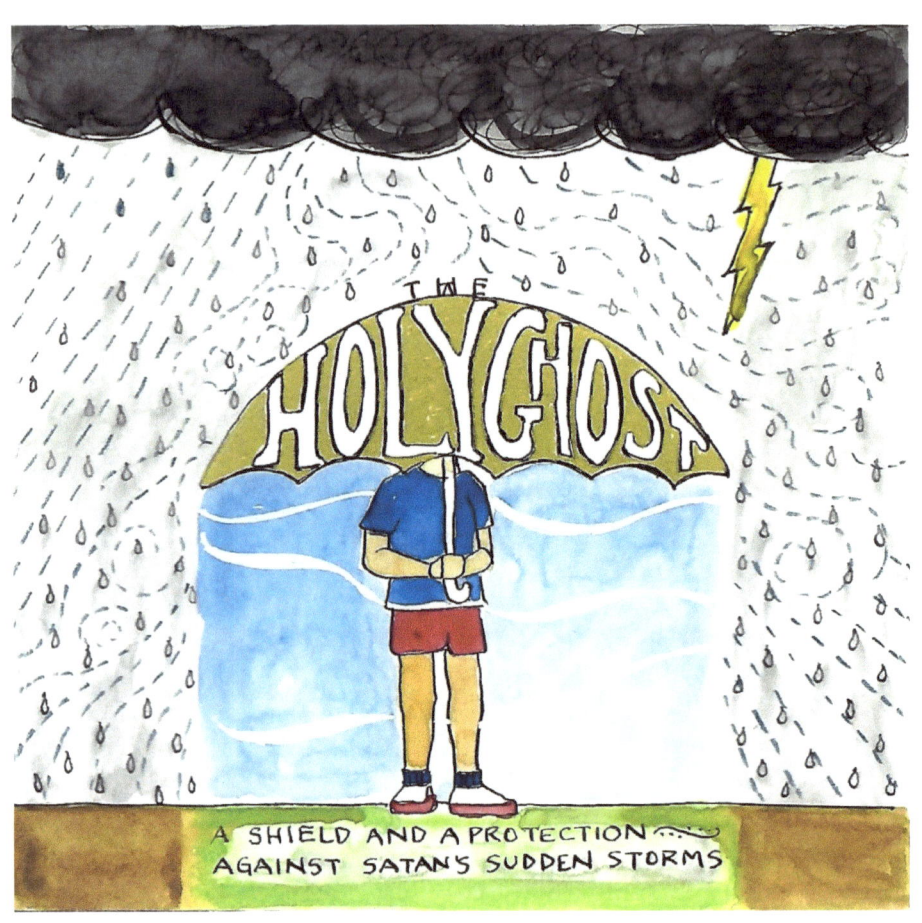

The Holy Ghost

When the skies are dullest grey,
And it looks like rain may pour,
My tightly gripped umbrella,
Always walks me out the door.

I'd be a fool to leave it,
Why go face the storm alone?
I would get soaked to the skin,
And the fault would be my own.

When sudden storms from Satan,
Break o'er your tormented life,
Be sure and take the Spirit,
To keep you morally dry.

He will protect and guard you,
According to your heart's choice,
What he can do depends upon,
The heed you give to his voice.

10/17/15

Commentary p68

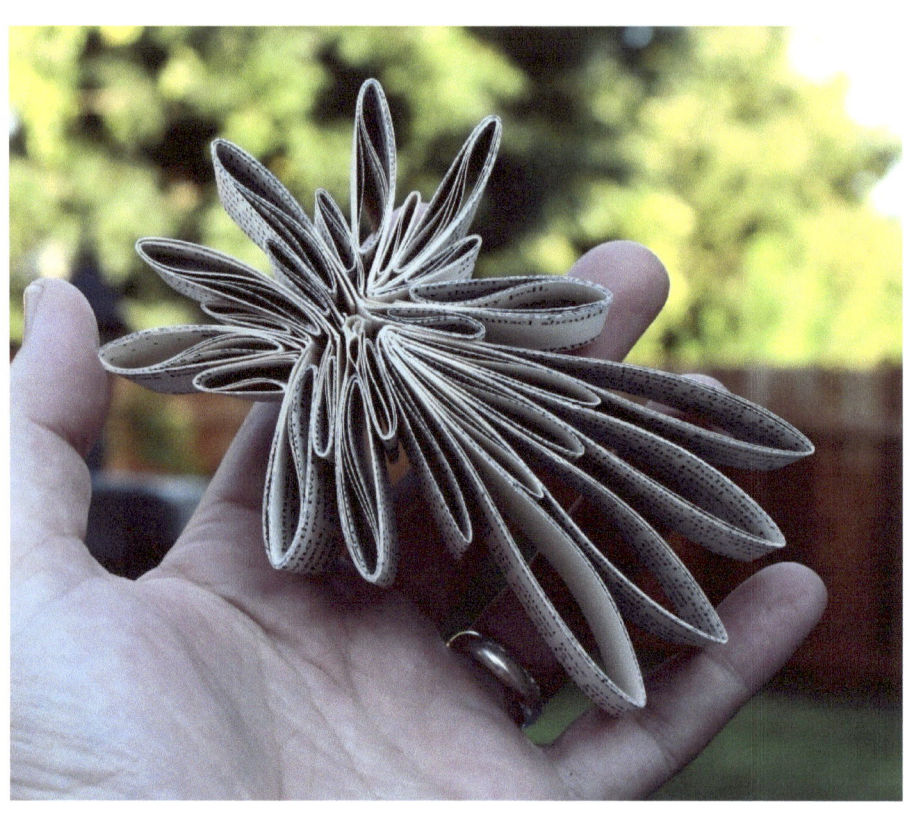

The Written Star

In ancient times stories were,
Only spoke or sung,
There was no way to transport them,
Through space or time to come.

But then one day a brilliant star,
Fell unto the earth,
With it brought the written word,
A gift of infinite worth.

To the cloud of knowledge,
The star's impact did leave,
They built a glorious monument,
And called it a Library.

10/17/15

Commentary p69

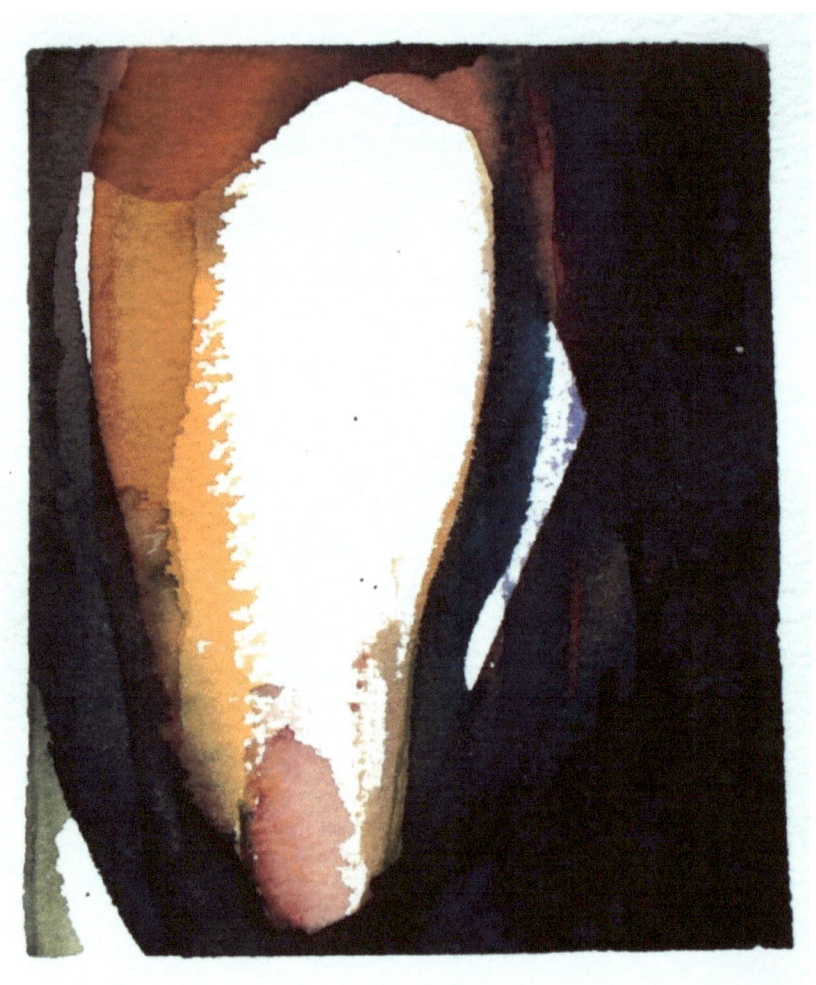

Emergence

No boy had ever kissed her,
The girls were all unkind,
And though she tried to make friends,
Close ones were hard to find.

Then after school was over,
When life began for real,
She could hide from loneliness,
In books her heart could heal.

But tonight she's dressing-up,
Gonna paint the town red,
Show them all what they have missed,
How far her love could spread.

Out she walked into the night,
Fabulous, head to toe,
Finally as beautiful,
As what's inside, I know.

10/15/15

Commentary p70

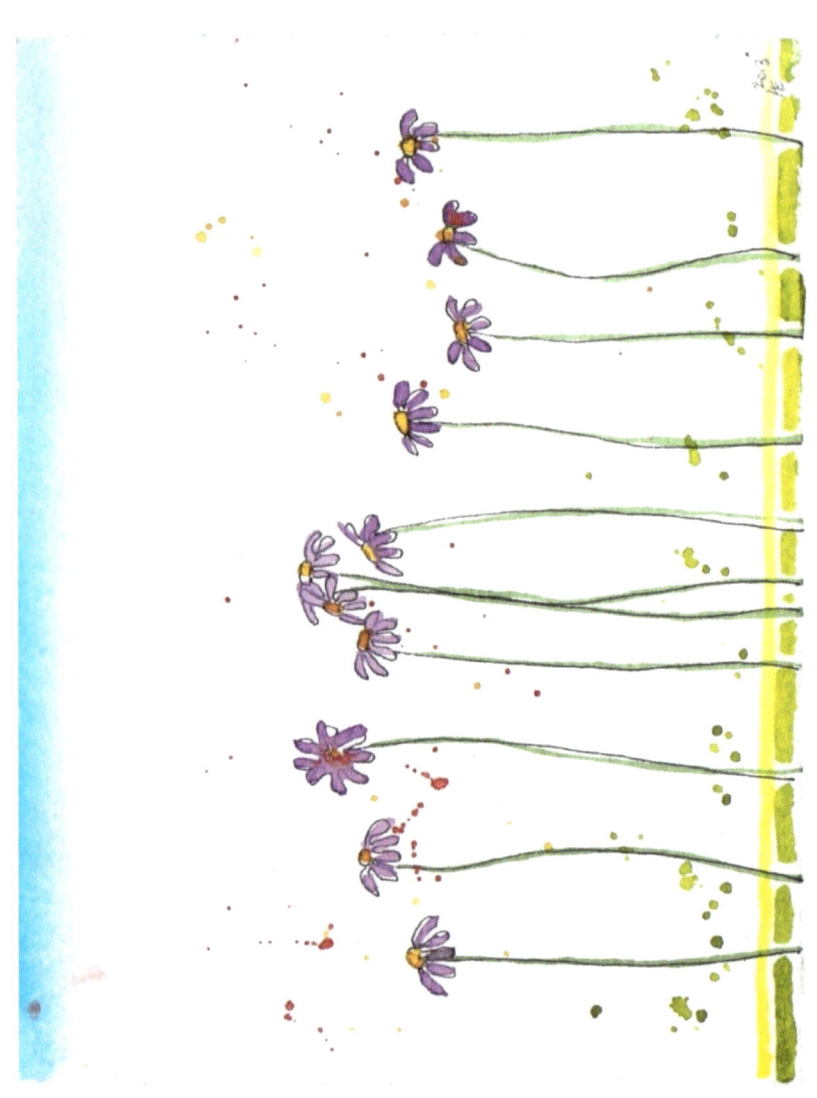

Asters

Some lovely little asters,
Growing tall in summer grass,
Reaching up toward the sun,
Spread their petals wide at last.

The tallest one looked around,
Then said this to his fellows,
"I think maybe I'm the best,
'Cause you're all so far below."

The second bloom sniffed and sneered,
Then he answered with a scoff,
"I think you are less than best,
Half your petals have fall'n off."

But then the smallest aster,
Looked down at the others,
From the hand of little Sue,
"The best one goes to Mother."

10/14/15

Commentary p71

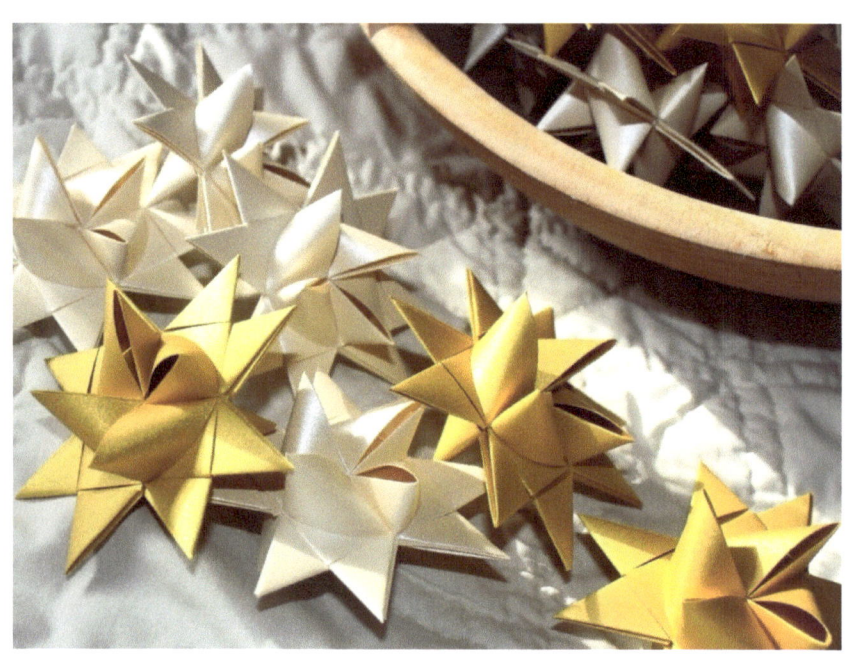

One Among Them All

A billion stars spread far and wide,
Quite beautiful to see,
Their happy glow of gold and white,
Blend o'er a peaceful sea.

I gazed upon them through the night,
And noticed one so small,
It hardly gave off any light,
T'was hard to see at all.

Something about that little star,
Kept drawing back my gaze,
It's glimmer had come oh so far,
Flickering were the rays.

But, the clarity of its shine,
Surpassed those I had known,
Helped me learn they each had a fine,
Perfection of their own.

10/18/15

Commentary p72

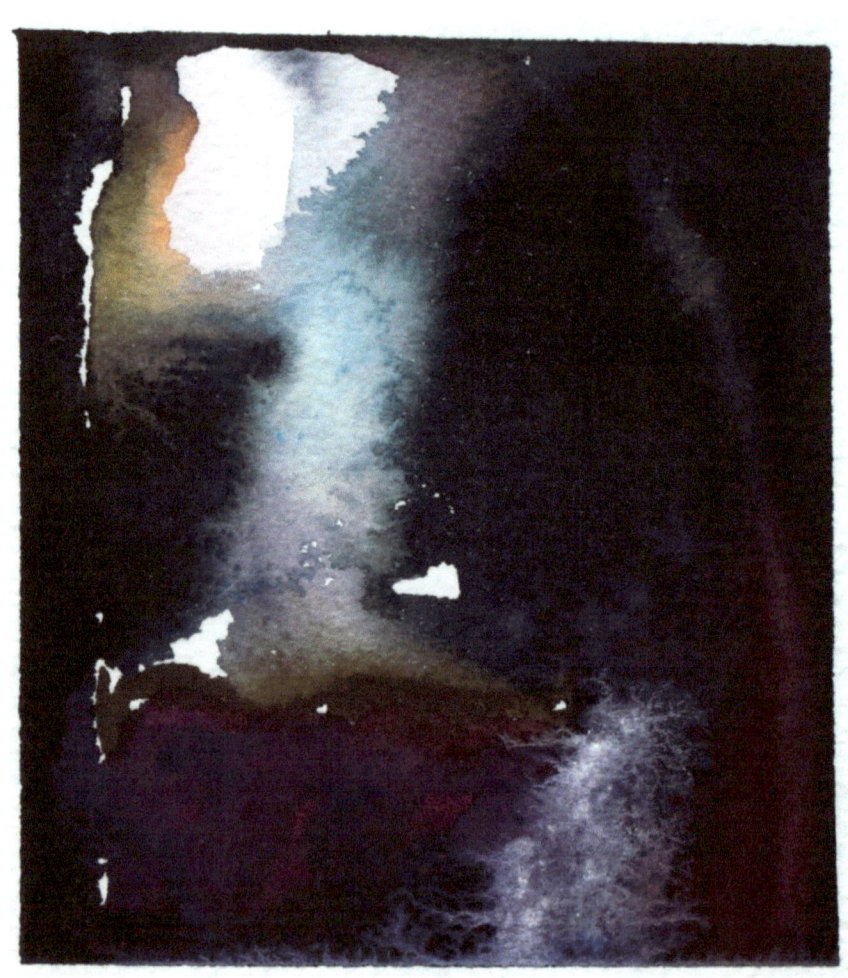

Darker than the Blues

In the back rooms of my mind,
Where I never ever go,
It's so dark I turn blind,
I'm things you don't wanna know.

Yea that's where my hatred,
And my anger live,
That part of my soul's dead,
Murdered by all that you did.

It drags me down to midnight,
When I enter that room,
Sometimes it's too much to fight,
Turns me darker than the blues.

There is no man out there,
Who can hate like I can,
I'll hurt and I don't care,
'Cause I'm a fierce fierce man.

With the darkness upon me,
It's a heavy load,
God's mercy can't touch me,
Or so I've been told.

It'll take a good woman,
To block-up those rooms,
Only her perfect lovin' can,
Save me from bein', darker than the blues.

10/9/15
Commentary p73

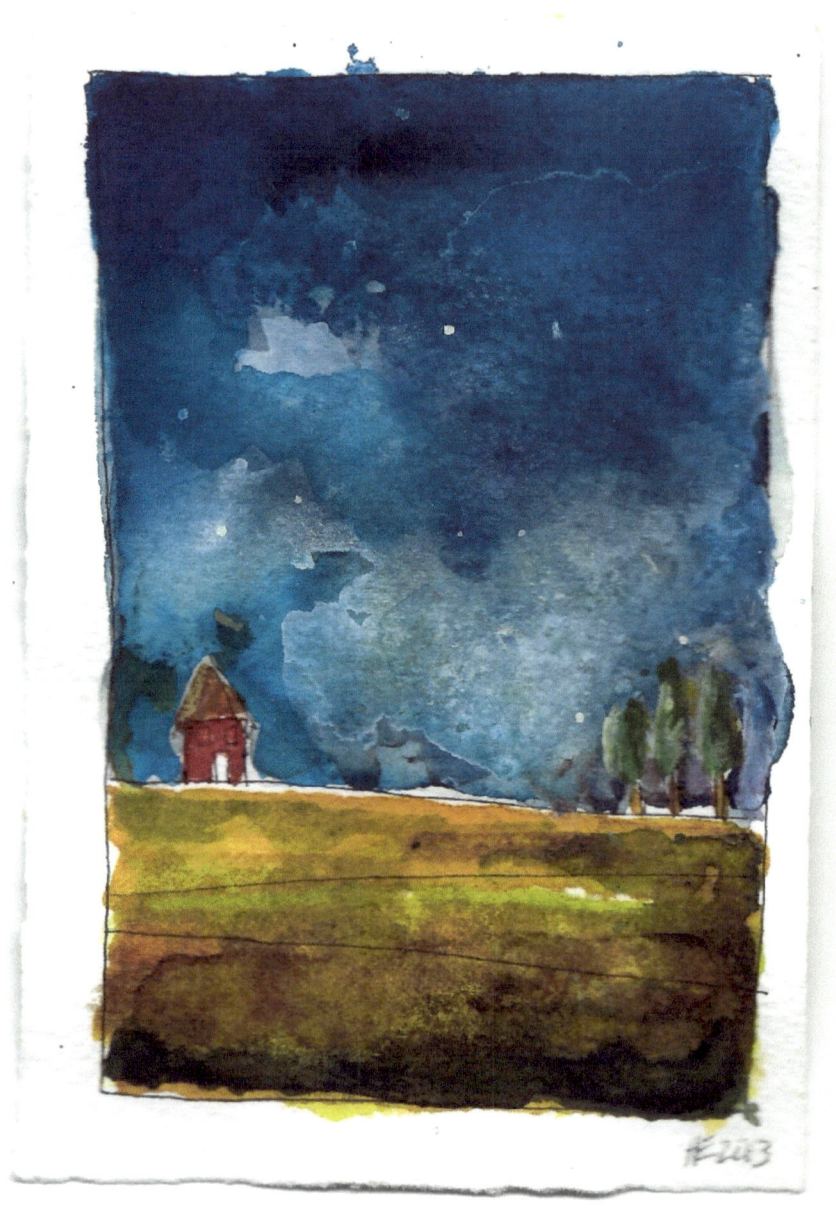

**The Little Red House:
Darkest Before the Dawn**

In the night of solitude,
When whispers echo loud,
Voices tell me I'm not worth,
Loving, 'cause I'm so proud.

They try to poison my very soul,
With half-truths and vicious lies,
I slip, I sink, but reach up still,
The spirit in me cries,

"God, I never asked for much,
In a potential mate,
Just send me one who loves Thee,
The rest 'll leave to fate."

Then a knock upon my door,
E'en as my spirit sagged,
A handsome man was standing there,
In his hands, two loving bags.

10/18/15

Commentary p74

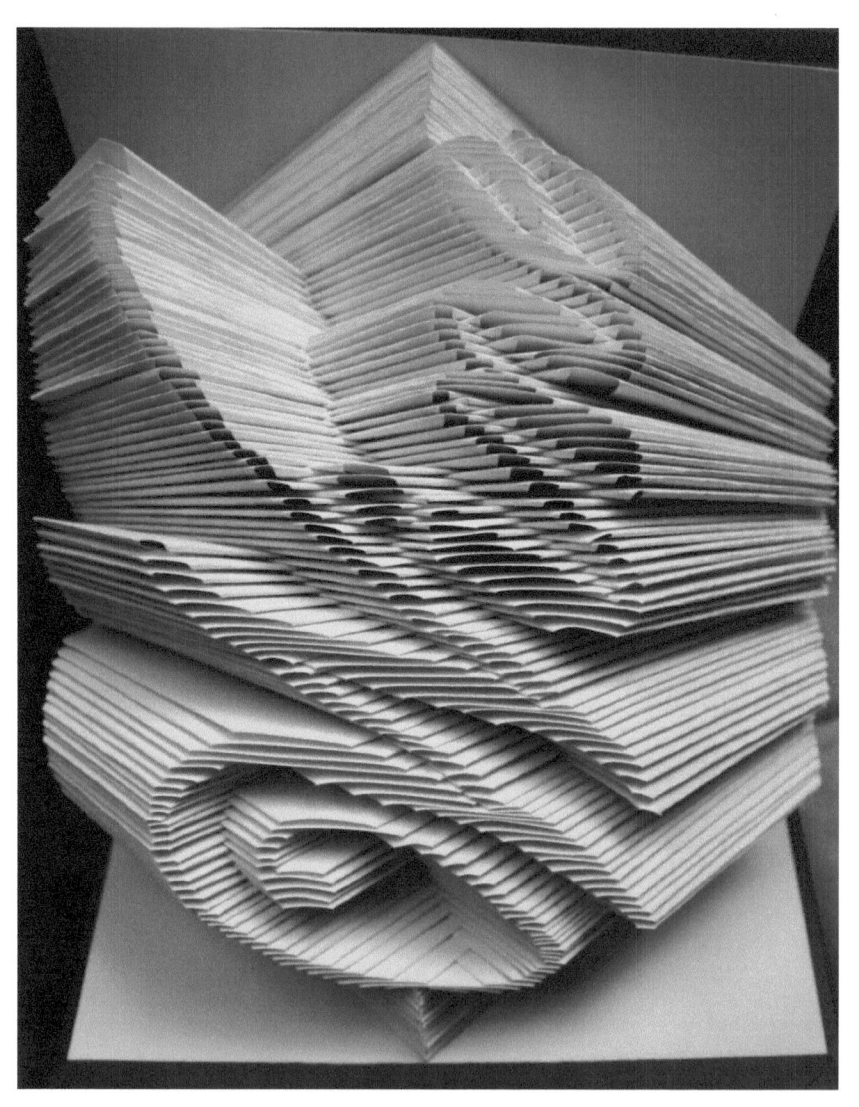

Wine

A liquid jewel in the glass,
Swishing, flashing in the light,
The fruits' blood, given for me,
A remarkable delight.

In vino veritas they say,
And it does loosen the tongue,
A warmth flowing to the heart,
Deep down, cheerful songs are sung.

Heady perfume wafts through space,
The nose savoring its sting,
Lips tremble, anticipate,
The sweet full pleasure it brings.

I hoist the glass to salute,
With my friends a gentle clink,
And now the moment has come,
I lift, I tip, then I…

10/14/15

Commentary p75

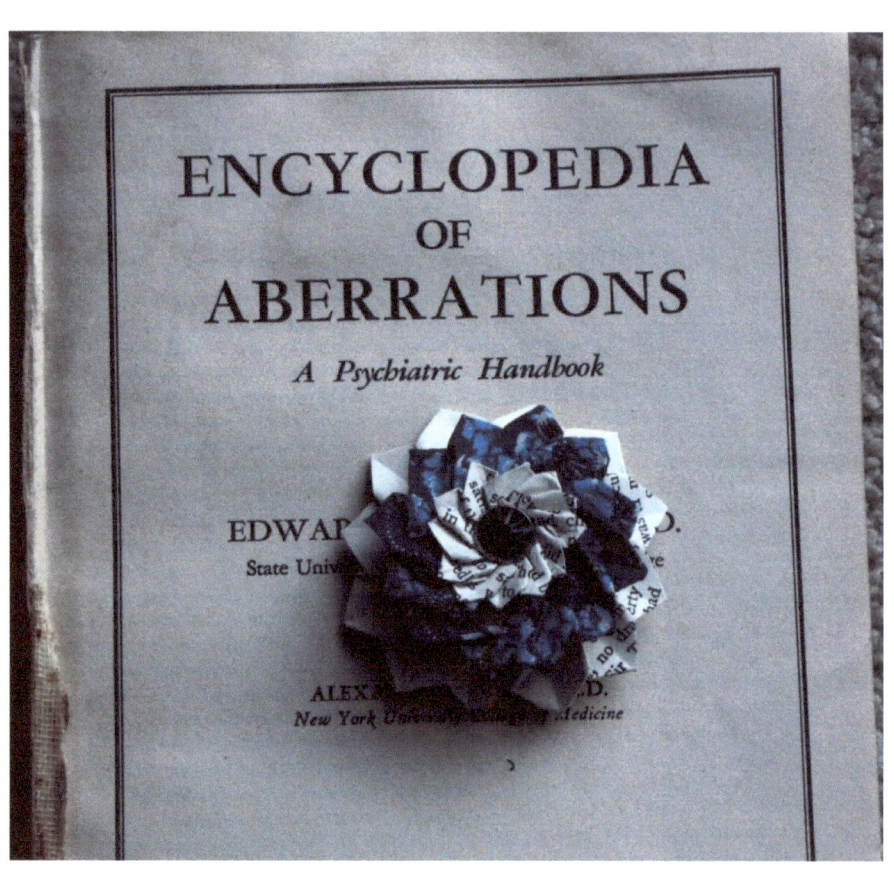

Aberrations

Elements will shine out bright,
When filled with energy,
And how they're put together,
Determines what we see.

Copper burns a brilliant blue,
Sodium glows yellow,
When they are put to the flame,
By the light are they known.

People are somewhat the same,
All types of weird inside,
When they're stressed or maybe blessed,
Truth cannot be denied.

So when your inner quirks are,
Excited to be seen,
Pray the only ones you have,
Will bring forth true beauty.

10/18/15

Commentary p76

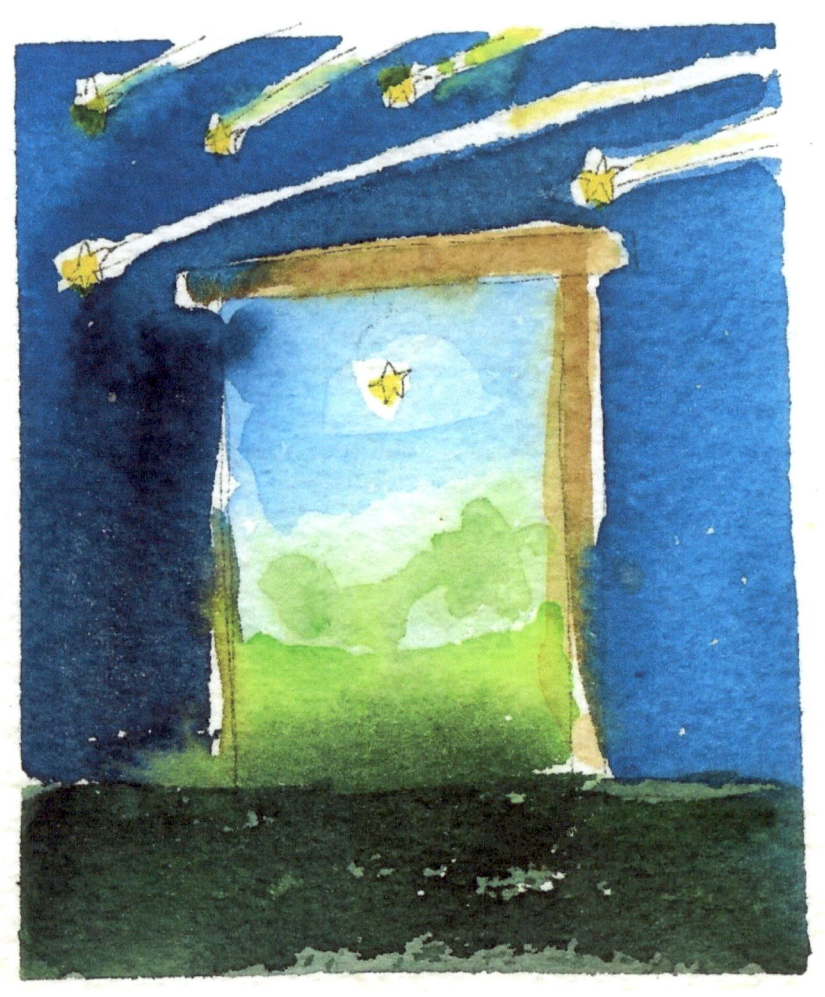

Through the Gate of Night

The sky is surging, ground is lurching,
Waters heaving, air is seething,
The wicked running, the End is coming,
Light is failing, endless wailing,
Contemplating, doom awaiting,
Judgement pointing, eyes averting,

Silence reigning, mercy gaining,

Tears are streaming, souls a-gleaning,
Angels leading, wisdom heeding,
Loved ones finding, forever binding,
Night is fleeing, the Truth seeing,
From glory reeling, at feet kneeling,
All hurts healing, as His sealing.

10/18/15

Commentary p77

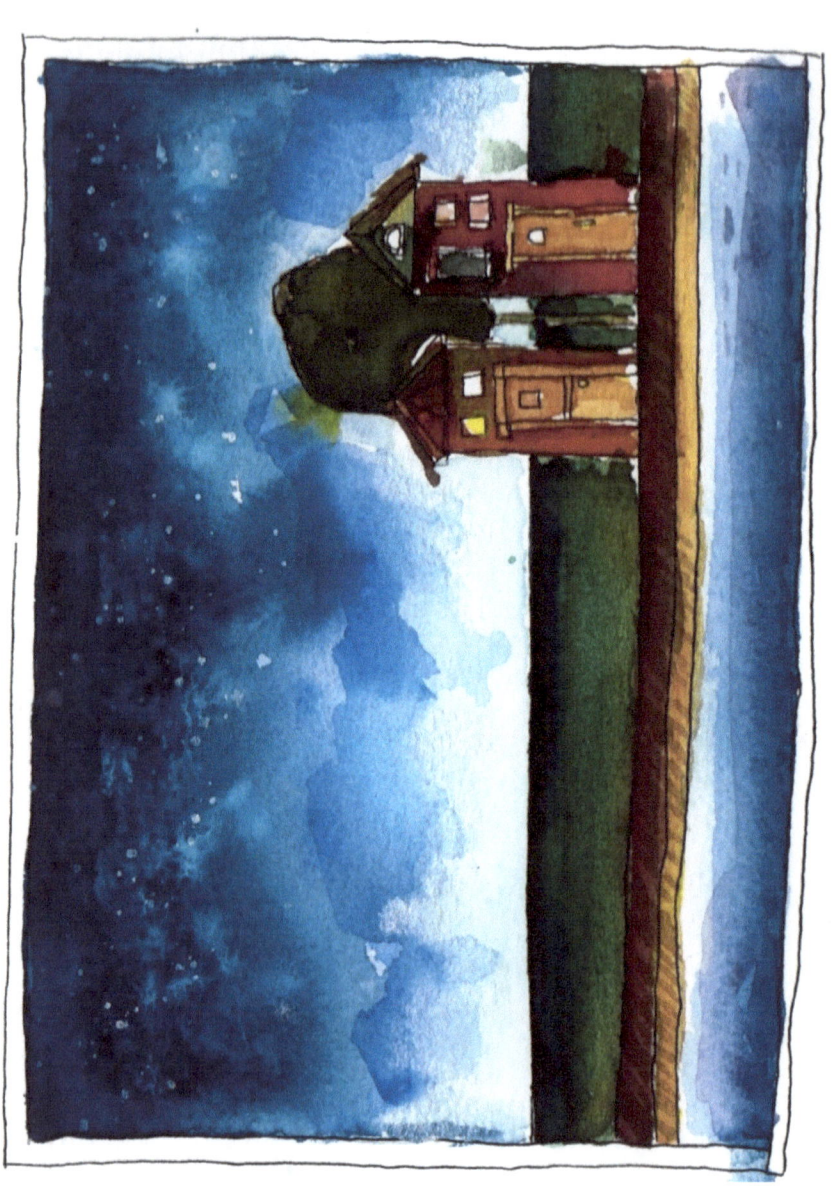

The Little Red House: Duplex

I always said that I would take,
 Whomever God decreed,
I always said that with His will,
 Whatever, I'd agree.
I always said that I would wait,
 We'll see what we shall see.

I never felt a giddiness,
 Though he makes me laugh,
I never felt to chase the moon,
 Though he gives me all he has.
I never felt that he's The One,
 Though he's good enough by half.

Now that he has come at last,
 Begin a chapter of my life,
Now that his arms hold me tight,
 It frees the passion deep inside,
Now that he has claims on me,
 I'll know the joys and pains of Wife.

10/18/15

Commentary p78

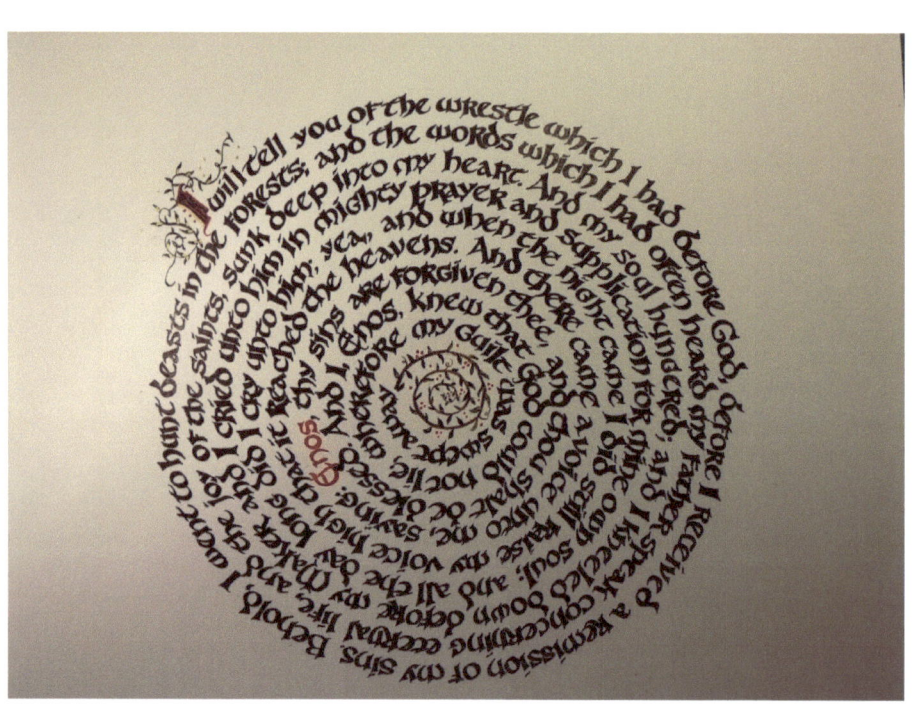

Enos

Hunting for the wild beasts,
That my family may be fed,
In the forest, on my knees,
I prayed to God instead.

Hunting for my very soul,
That I might be saved,
I found the Iron Rod, took hold,
It led me from the grave.

Hunting for my people's fate,
That they might be spared,
Petitioned God, don't close the gate,
Hold back judgement prepared.

Hunting for my enemy,
That among them might be who,
Would accept Thee willingly,
And Thy Savior's lasting truth.

10/18/15

Commentary p79

Greatness is best measured by how well an individual responds to the happenings in life that appear to be totally unfair, unreasonable and undeserved

M J ASHTON

Greatness

If I am hated by another,
When they should treat me like a brother,
I simply ask them why.

If my true love now is lost,
Because her heart has turned to frost,
I weep and wonder why.

If my child is lain in the grave,
I tried, I tried, but could not save,
I scream at God, "Oh why!?"

If we can but live His will,
By His wounds our souls can heal,
Overcome the why.

10/20/15

Commentary p80

Commentary

Fall is in the Air p2 (w)

Most of Heather's artwork is a bit of a mystery to me, either abstracts or basic landscapes. There are a fair number of simple shapes as well.

Every once in a while though, I discover something which tells a story. Whether it is the story Heather intended or not is certainly a question only she can answer.

To me, *Fall is in the Air* certainly tells of a small family walking through the woods and enjoying their time immensely. I sense Heather's great desire to have that family of her own and the fulfillment which it brings. I hope I have brought her some semblance of this joy.

The Little Red House: He's Here p8 (w)

Having also married later in life (27), I can understand the sense of emptiness Heather may have felt as the years went by and her younger siblings and friends all got married and had children. It can be overwhelming when the one thing you most greatly desire is also denied you.

My poem expresses some of her feelings when a man entered her life. He seemed wonderful at first, and then slowly she realized how imperfect for her he was. In time she wanted more righteousness than he was willing to live.

White Purple and Gold p10 (p)

A friend of Heather's asked her to make a bouquet of paper flowers for her wedding. The "handle" was a glass test tube with a cork in it. Heather and I joked about the couple sneaking sips of wine to fortify them through the ceremony.

Who is Out There? p12 (w)

There was a fair amount of residual angst inside me after writing *The Little Red House: He's Here* p8. Hence, *Who is Out There* is practically an echo or refrain of the earlier search for love. Honestly, I spoke those words many times in my early 20's.

Wizard Tim p14 (w)

It is not so easy to think of something to say about a bunch of flowers. Try it and you'll see. All the normal ideas of love and purity were taken by other poems. I was struck by the intense red, almost flame-like color of these blooms. That led me to question how a flower can burn and yet not wilt. The answer is, of course, magic…

A Multitude p16 (b)

The cultural differences between America and Europe regarding personal space are quite striking. Strangers will share tables in a restaurant, seats on the bus and stand very very close to one another. Looking at Asia makes a Yankee wonder how anyone can even breathe.

The Western American ideal of wide open spaces is completely foreign to most of the world and so a debate rages about what it means to live in close together. How does it affect us as individuals and a society?

I have opinions but no answers.

What a Mess p18 (w)

Bookshelves in the Eddy home are generally a chaotic jumble. Big heavy books and sets will migrate down to the bottom shelves and the lighter reads move up, being stacked atop one another wildly. This watercolor is in fact a fair representation.

The Little Red House: Why? p20 (w)

The end of any relationship is always accompanied by the terrible, "why?". "Why did he do this horrible thing?" "Why did she cheat?" More often than not, the next question is, "What's wrong with me?" We always ask ourselves. Sometimes we ask our friends. And then we ask God.

Perhaps we've all asked these questions. Perhaps we'll never know the answers.

Adam's Apple p22 (p)

Was Adam a sinner? Yes. He transgressed God's will regarding the "apple" (the Bible doesn't actually say an apple but…). Was it by his act that death entered the World? Not really. Eve was the first and she would be cast from the garden, losing her perfection and thus subject to death regardless of Adam's decision. See, Adam could have stayed in the garden by continuing to refuse the apple. But then mankind would not have come about and the entire purpose of this earth frustrated. I prefer to think of Adam as a wise and selfless man who willingly gave-up a perfect life in order to remain by the woman. Remember, God commanded them to remain together and multiply. They could not have done this unless both ate.

Nitwit p24 (c)

We are Harry Potter fans and, like Harry himself, thought Dumbledore's pronouncement to be hilariously daft.

As with an earlier poem (which was later discarded) I took each of the words from this quote and used them to head a stanza.

For anyone who might not have followed…think Neville.

Starscape p26 (w)

Countless individuals have looked at the vast expanse and seen it as proof that God exists. Others have seen the chaos and random nature as proof that nature alone rules us.

Myself, I see order in the universe and believe that Man is simply not yet ready to understand those things we do not know.

Any honest scientist would have to attest that this view is more consistent with the Scientific Method than any pronouncement that we "know it all".

Hearts p28 (p)

Yes, I was being naughty. Sue me.

The Holy Ghost p30 (w)

Heather and I were teaching a Sunday School class for 16-17 year olds and I needed a good metaphor to explain how the Holy Ghost can work in our lives to protect us from evil. Inspiration came (because I am completely incapable of making up something this good by myself). Satan and his influence are like a constant rain storm. If you walk out in it, you will get drenched. The Holy Ghost is like an umbrella. First you have to take it with you always, then actively open it against the rain and finally, stay within its protective shield. Any deviation from right decisions leaves you exposed.

The Written Star p32 (b)

This folded star is very different from any other I have seen Heather make. It is so obviously a shooting star that I felt it deserved a special treatment.

Made with folded book paper, and remembering the current vogue that life came to the earth on a comet, it wasn't too great a step to imagine the written word arrived the same way and spawned all the books and great temples to reading that are libraries.

Emergence p34 (w)

A woman's painted fingernail. Why would that be a subject worthy of a poem? Was she a socialite? Did she dress-up often? No, I was much more interested in a woman who had never been out on the town. What made her decide to step out in public now? Was she finally finding herself? I hope she finds her confidence.

Asters p36 (w)

These little purple flowers at once struck me as a group of teenagers, with all the competition and comparison that entails.

I had to look at several pages of flowers before deciding they looked like asters. Frankly, I thought they were purple daisies.

One Among Them All p38 (p)

These are, to me, the most beautiful of all Heather's paper art. There's something special and grand about the satin texture and precision of the folds. They are wonderful.

You might have noticed a recurring idea of the one small, insignificant member of a group who does well. I often felt like the underdog.

Darker Than the Blues p40 (w)

This was by far the darkest of Heather's watercolors, not only in luminescence but in the palette as well. It felt like being deep in a very scary cave. I am ashamed to admit that I was angry at Heather at the moment I began to write this, we having had a fight about something incredibly stupid.

It was painful, admitting to such darkness in my soul.

The Little Red House: Darkest before the Dawn p42 (w)

This poem was driven more by the plans rather than the image. Having outlined the *Little Red House* poems roughly on Heather's life, it was simply time for one about dealing with disappointment. The dark sky fit well with the overall tone while the lighter horizon promised an eventual dawn.

Wine p44 (b)

This is fairly self-explanatory. The funny thing is, I'm not a drinker. Perhaps some of my more inebrious friends could comment on how well I captured the feelings involved.

Aberrations p46 (p)

Heather likes to collect interesting books. What possessed her to position this flower with the Encyclopedia of Aberrations I have no idea. Yet when I saw the picture there was no way it could be excluded from the collection.

At first I wanted to talk about the beauty to be found in oddity but the words wouldn't flow. Eventually, as a third choice, I considered the manner in which different elements glow.

Through the Gate of Night p48 (w)

C,S, Lewis' *The Last Battle* is a masterpiece of commentary on the relationship between the "Christian" and "Non-Christian". His description of the end of the world is both dramatic and frightening. I couldn't ask for better material from which to crib.

The Little Red House: Duplex p50 (p)

How great the joy when something wonderful, long expected but only dimly understood, finally comes into one's life.

Enos p52 (c)

The Book of Enos within the Book of Mormon tells the story of a man who sought redemption. He prayed all day for personal forgiveness and then, gaining a witness of God, proceeded to turn his thoughts to his people and their welfare. Hearing the Spirit of God promise to have mercy upon the people in so far as they were righteous, Enos then prayed for his national enemy who were implacably opposed to his own. For his greatness of heart, God promised him many grand mercies toward all who would follow the Lord.

A parallel concept can be seen in Abraham's discussion with the Lord regarding Sodom and Gomorrah.

Greatness p54 (w)

As Heather moved into calligraphy, I was faced with a greater challenge: How do I write a poem about a quote? Watercolors gave me a fairly blank canvass as it were but straightforward phrases leave me little room to be creative.

This wonderful statement about dealing with adversity not of one's own making is particularly poignant in my life with some of my trials.

Rejected

Heather has been very kind. In no case has she rejected any of my poems. Nor have I rejected any of her artwork (simply because I chose the art before doing any writing). Rather, in a few cases, she has felt the need to withdraw a work of art after I had already composed the poem. Her reasons are her own and I must respect that. Nevertheless, I like most of the poems and so share them with you sans image.

The Holy Ghost

I don't have a bodyguard,
To break-up the fights I'm in,
No, I have a spirit guard,
Who protects me against sin.

He knows all the Devil's snares,
What temptations are in view,
And my guard is well prepared,
Help me do what I must do.

But unlike a bodyguard,
Who must listen to *my* voice,
The Holy Ghost is a guard,
Only by my righteous choice.

10/17/15

 I was half-way through the poem before I realized it had very little to do with the watercolor. The imagery was all wrong. So I had to rewrite it into what you see on page 30-31.

About the Authors

Heather

Heather (Hajek) Eddy was born and grew up (mostly) in California; earned a BFA in watercolor and printmaking from Brigham Young University; and a Masters in Library Sciences from San Jose State.

Her art is an eclectic mix of watercolors, folded paper and anything which elevates the soul.

Original works and prints are available at Etsy and Society6

Brian

Brian Eddy is a semi-pro author whose books, *Psalms of My Life v 1-3, Mingos and Sharp Parts,* and *My Sister the Zombie* are available at online retailers.

He dabbled in Kung Fu San Soo for a number of years, earning an 8th degree Black Belt.

Brian likes to do things he's not good at like singing, dancing and being funny. Luckily he has close friends who mock incessantly to keep him in his place.

www.ingramcontent.com/pod-product-compliance
Lightning Source LLC
Chambersburg PA
CBHW041102180526
45172CB00001B/66